ittle
HIP

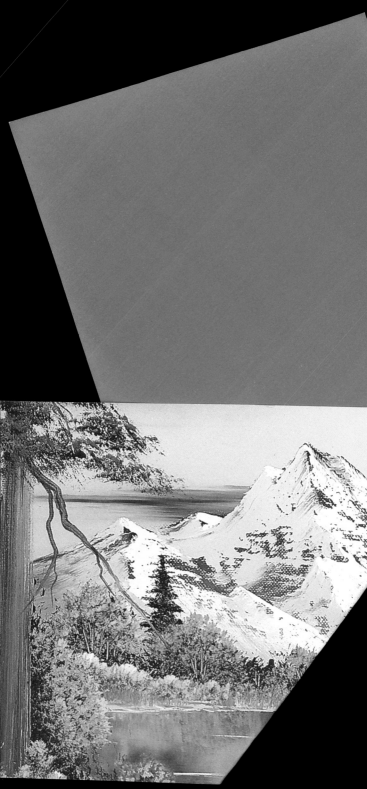

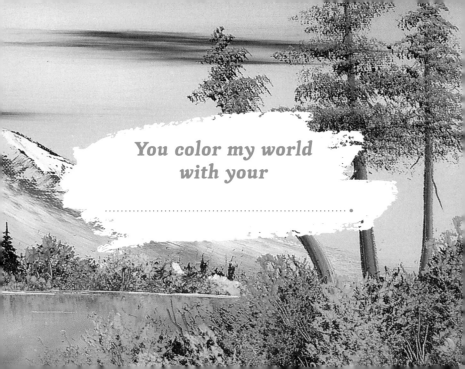

You color my world
with your

..

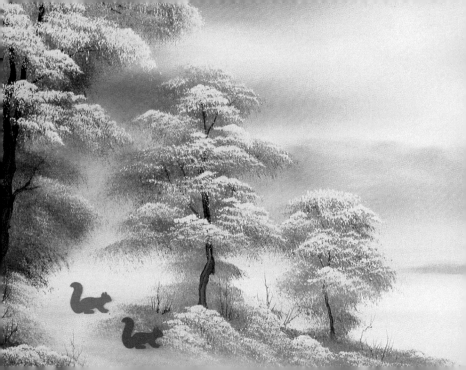

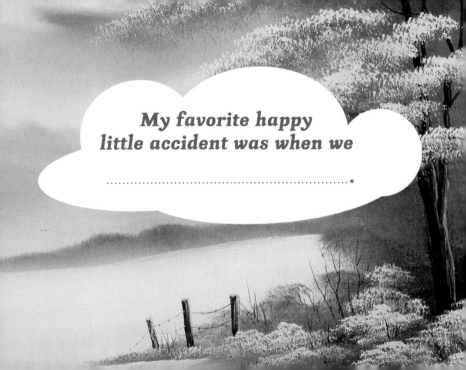

**My favorite happy
little accident was when we**

... .

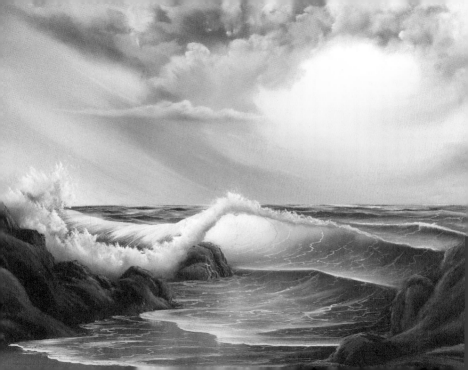

........................

***with you is the true
joy of our friendship.***

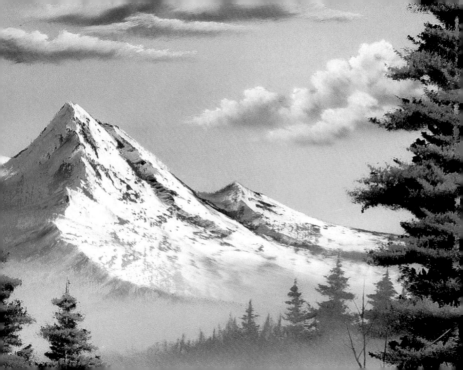

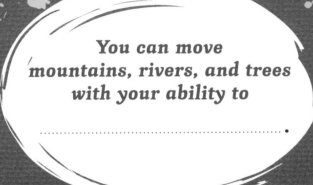

You can move
mountains, rivers, and trees
with your ability to

.. .

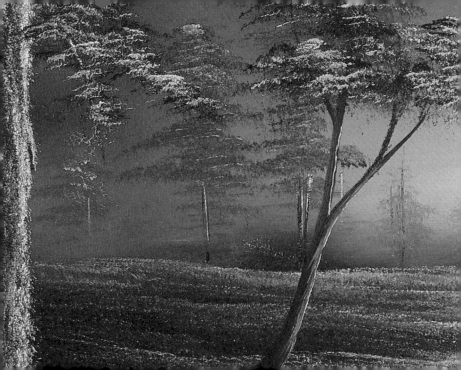

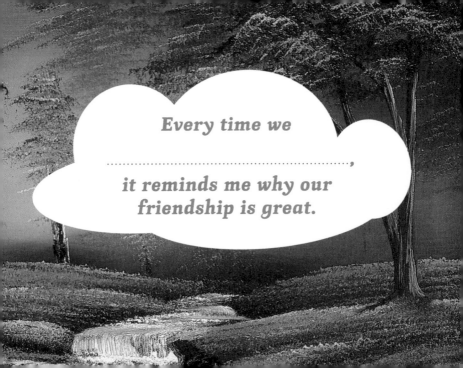

Every time we

..,

it reminds me why our
friendship is great.

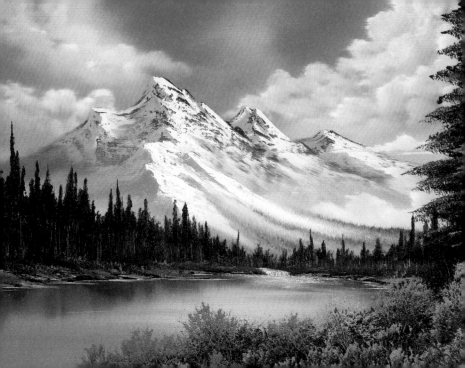

Just when I think
there are too many unhappy
things in the world, you

.. .

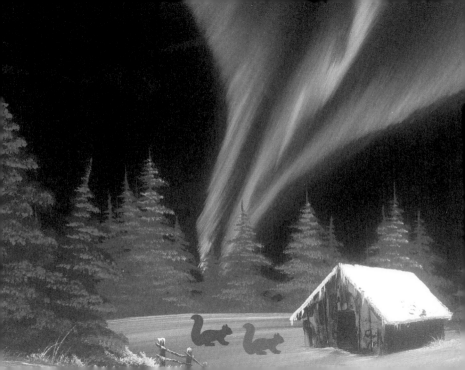

would be a good place for us to live together!

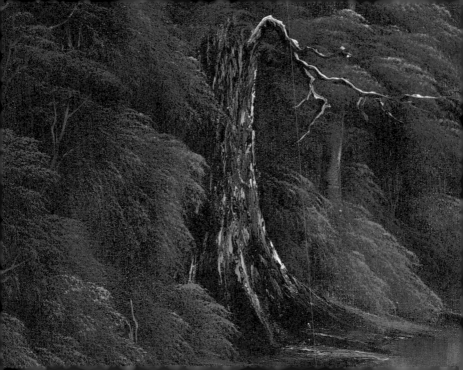

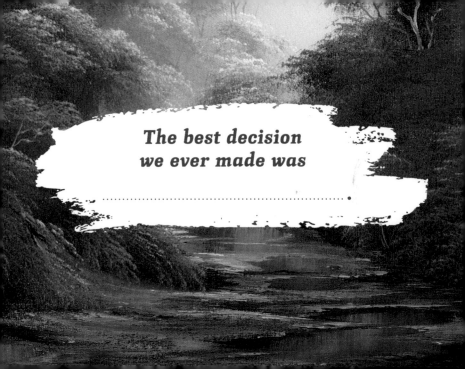

The best decision
we ever made was

......................................

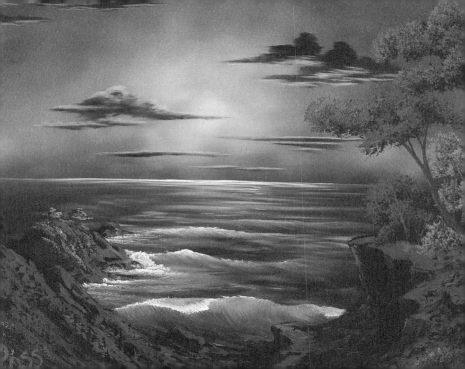

I admire the way you

... .

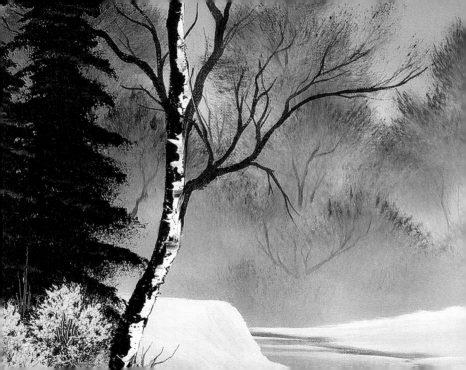

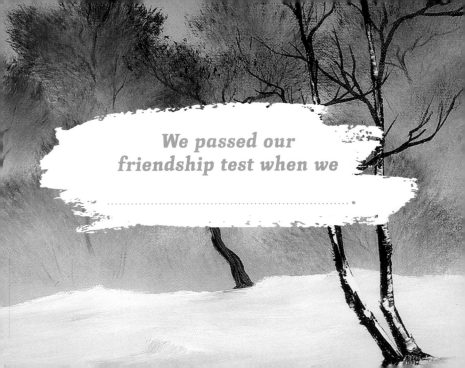

We passed our
friendship test when we

· ·

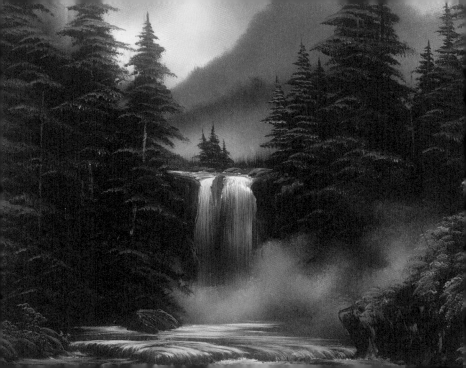

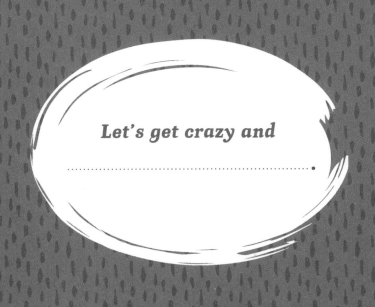

Let's get crazy and

..

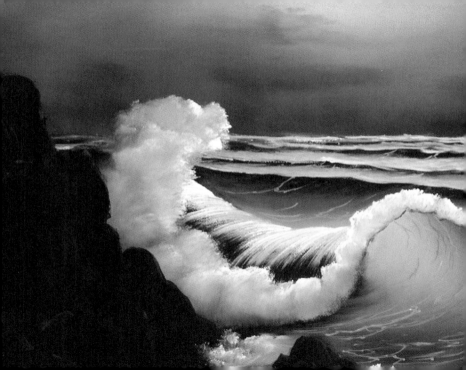

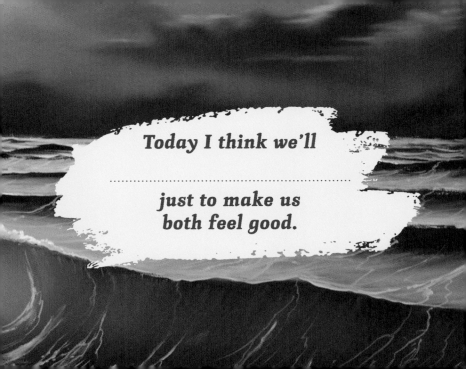

Today I think we'll

..

just to make us
both feel good.

If there's a secret to our friendship, it's

..

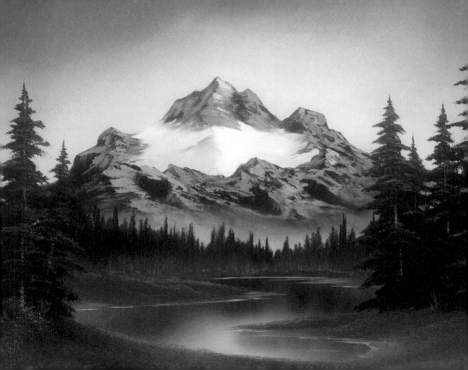

*Let's try something
new together, like*

...

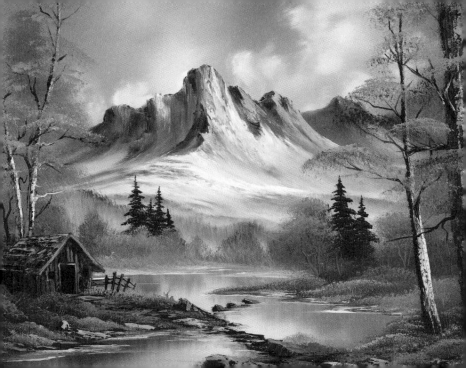

..

*is as individual as
our friendship is.*

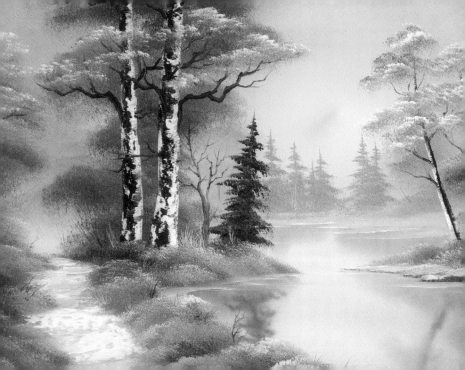

When you

...,

it makes me feel

...•

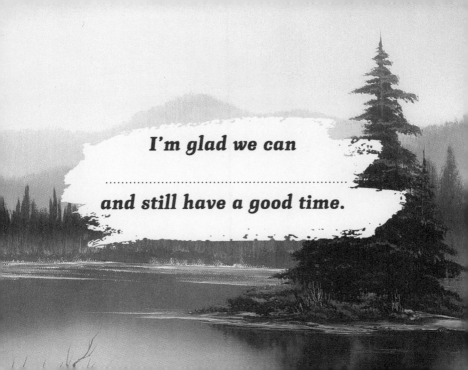

I'm glad we can

...

and still have a good time.

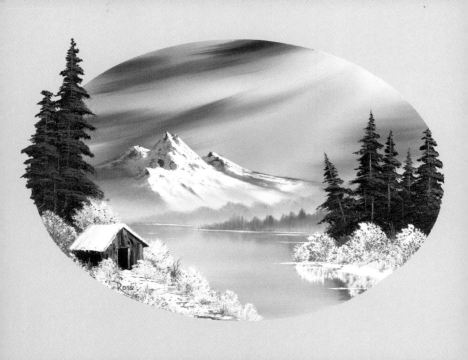

Sometimes,
when things like

..

just happen, they're
more beautiful than
things we planned.

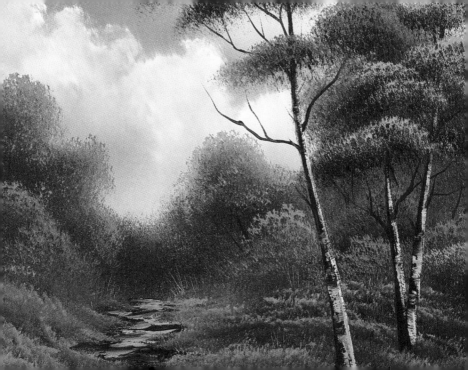

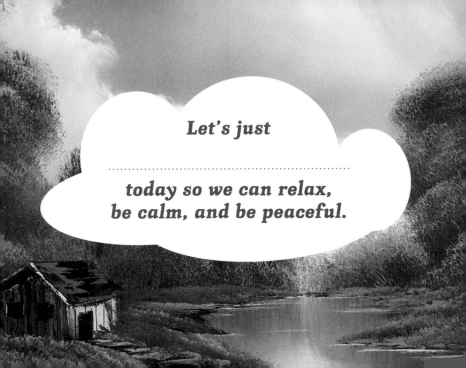

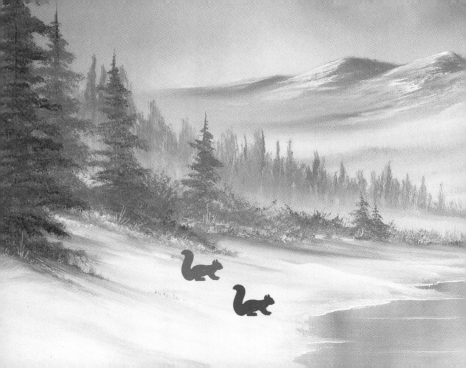

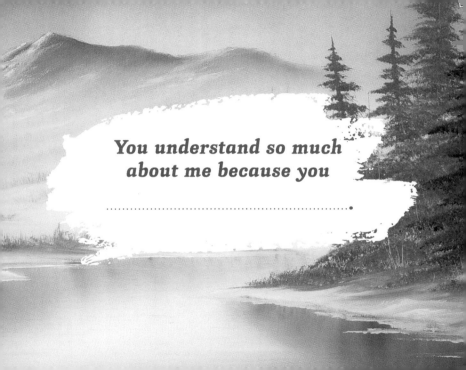

You understand so much
about me because you

· ·

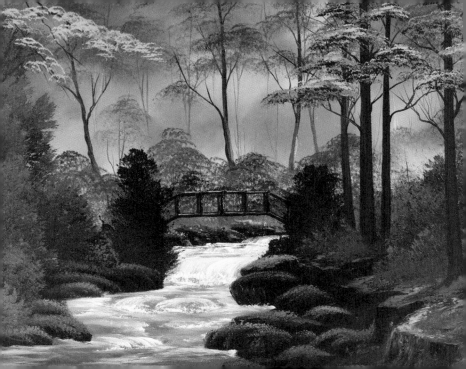

Did you ever think we could _____?

We can do anything when we're together!

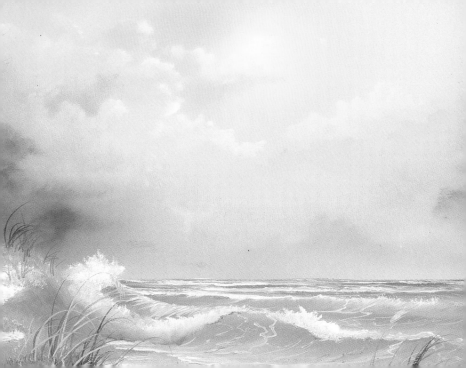

*in our friendship carries
over into every part of my life.*

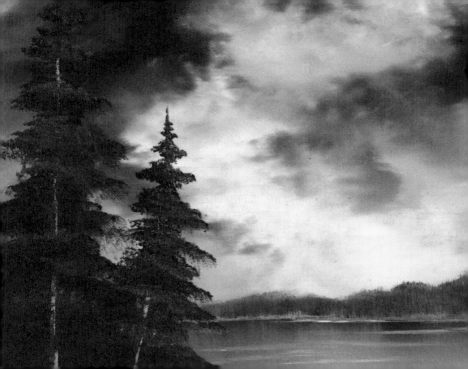

You make me
chuckle when you

· ·

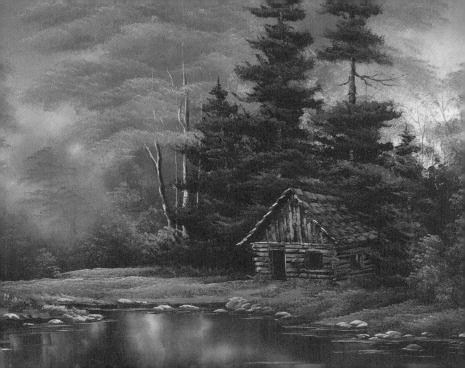

I appreciate life
and all the beautiful
things when you

..

You taught me that I could

...

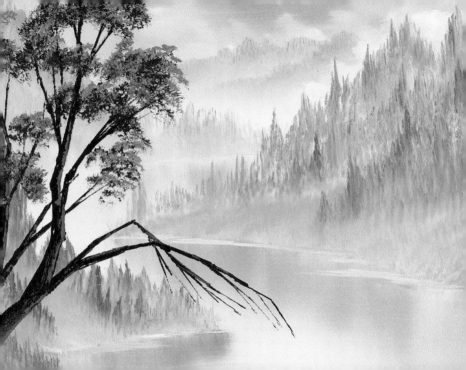

We're a perfect blend of

..

and

.. .

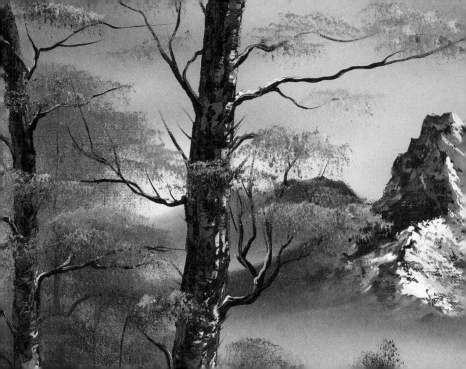

Let's climb to the top
of a mountain and

..

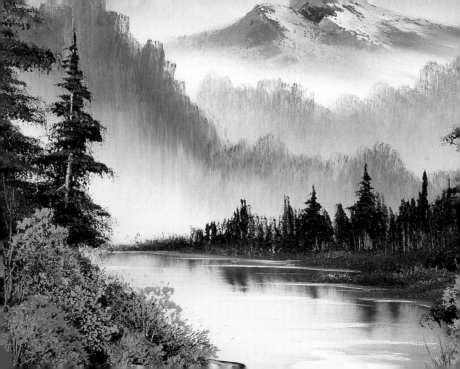

Let's talk about

...

*while we float
down a lazy river.*

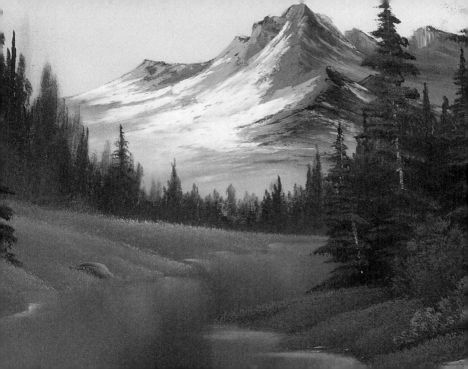

I'll pack the

..,

if you pack the

..

for our creekside picnic.

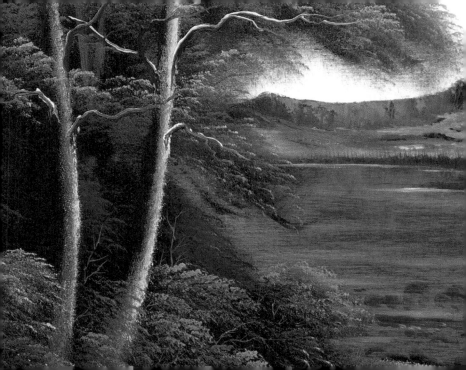

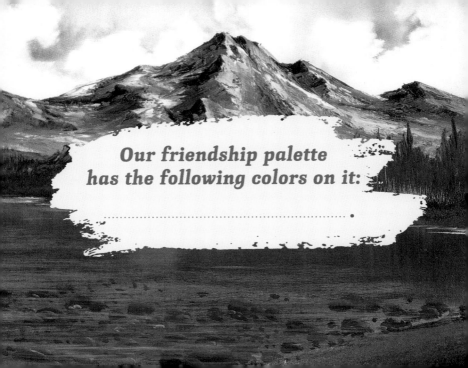

**Our friendship palette
has the following colors on it:**

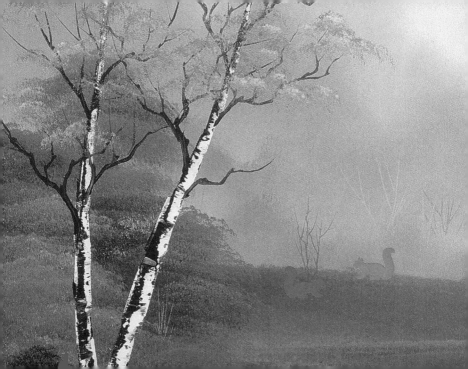

You supported me
like an easel supports
a canvas when

. .

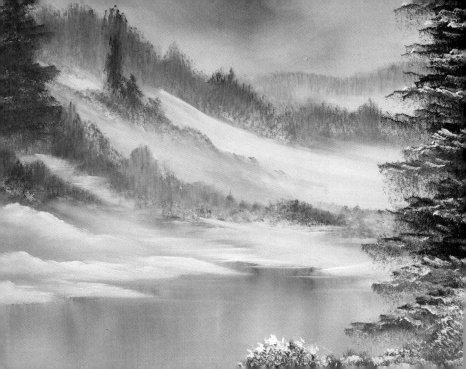

*I think your hair
looks fantastic when it's*

......................................

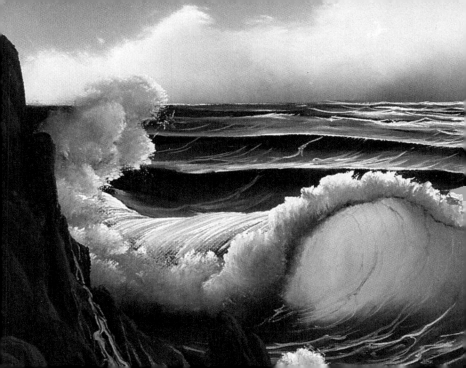

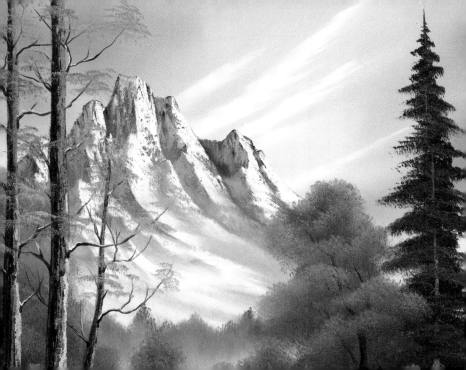

Let's make some

..

and have fun all day.

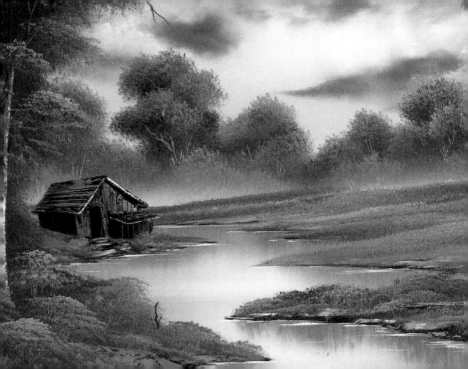

You can create all kinds of

..

Anything we don't like, we'll turn into a

... •

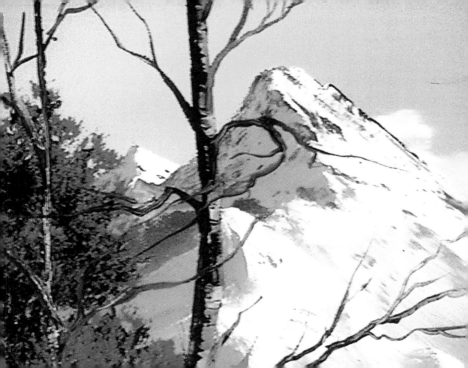

You're like a happy little

..•

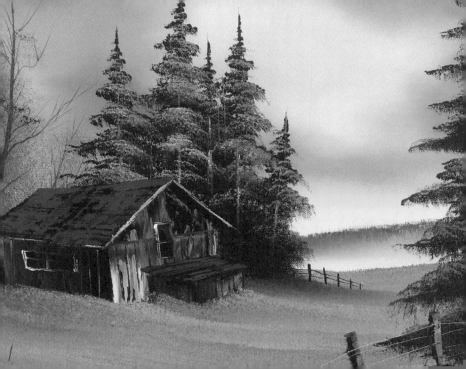

Let's find a cabin
in the woods and

..

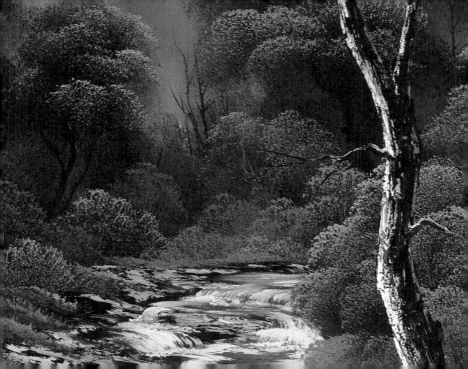

Let's

*just to make them
little rascals sparkle!*

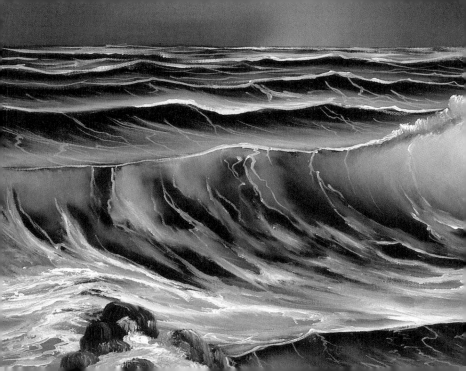

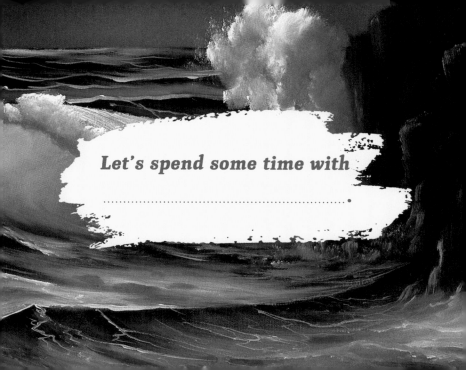

Let's spend some time with

..

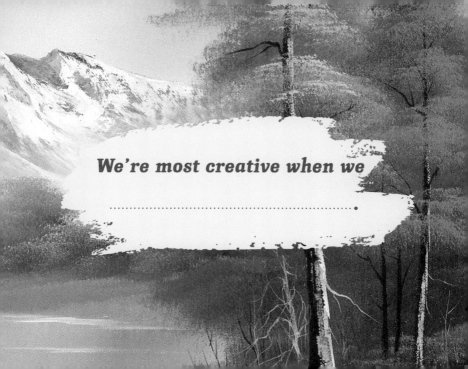

We're most creative when we

..

*If you've taught me
nothing else, it's*

..

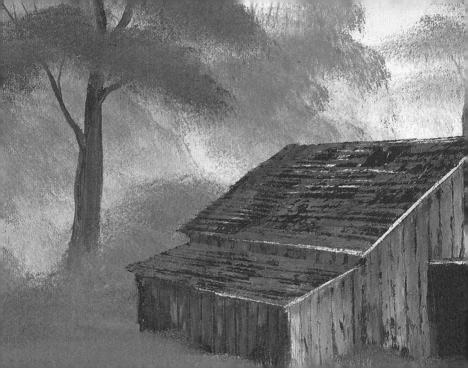

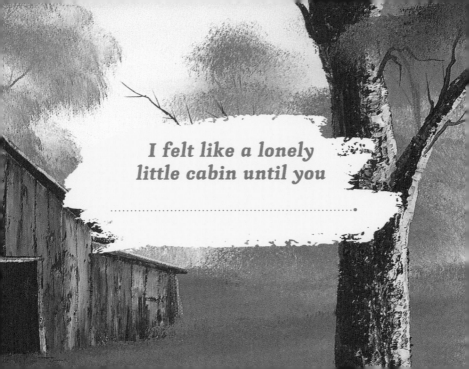

I felt like a lonely
little cabin until you

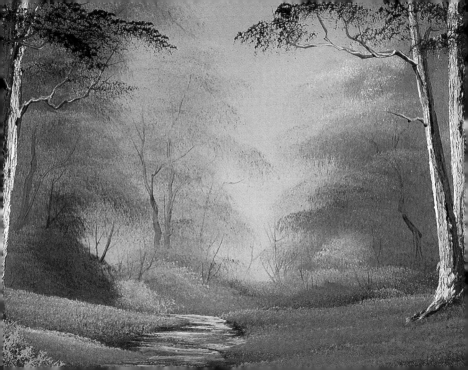

As long as

...

**makes you happy,
then it's fantastic.**

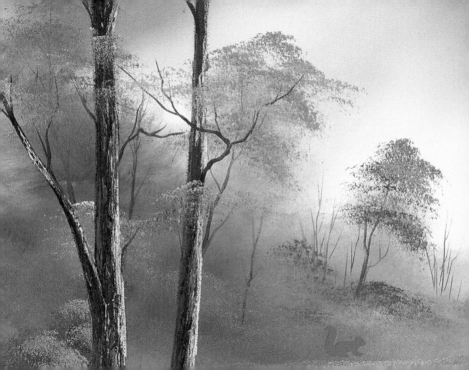

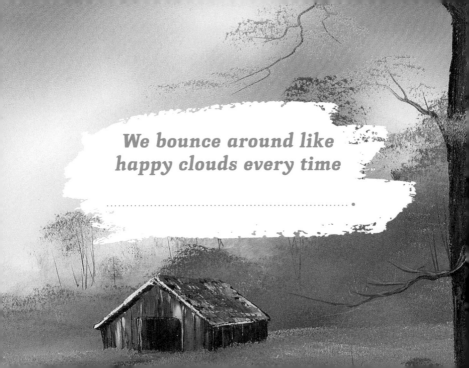

We bounce around like happy clouds every time

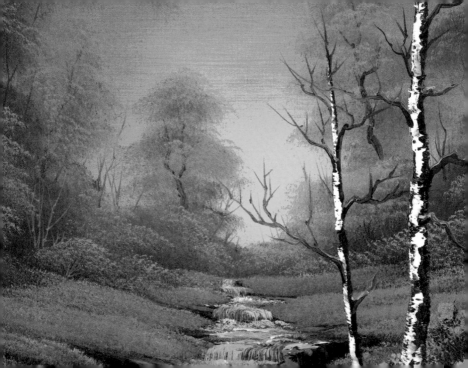

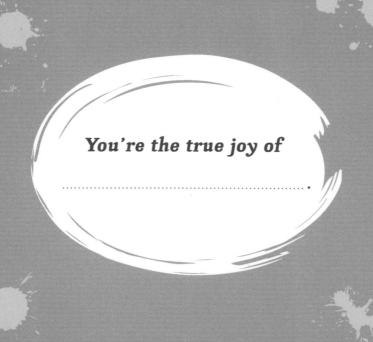

You're the true joy of

.. .

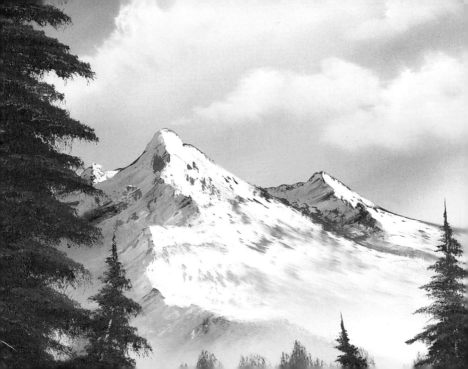

**The day we met was
the greatest happy little accident.**

Hachette Book Group supports the right to free expression and the value
of copyright. The purpose of copyright is to encourage writers and artists to
produce the creative works that enrich our culture.

The scanning, uploading, and distribution of this book without permission is a theft
of the author's intellectual property. If you would like permission to use material from
the book (other than for review purposes), please contact permissions@hbgusa.com.
Thank you for your support of the author's rights.

RP Studio™
Hachette Book Group
1290 Avenue of the Americas,
New York, NY 10104
www.runningpress.com
@Running_Press

Printed in China
First Edition: June 2022

Published by RP Studio, an imprint of Perseus Books, LLC, a subsidiary of
Hachette Book Group, Inc. The RP Studio name and logo is a trademark
of the Hachette Book Group.

The publisher is not responsible for websites (or their content) that are
not owned by the publisher.

Written by Robb Pearlman

ISBN: 978-0-7624-8034-0

1010

10 9 8 7 6 5 4 3 2 1